GARDEN OF EDEN

BEAUTIFUL BIBLE SCENES TO COLOR AND INSPIRE

GARDEN OF EDEN

BEAUTIFUL BIBLE SCENES TO COLOR AND INSPIRE

ZONDERVAN®
.com

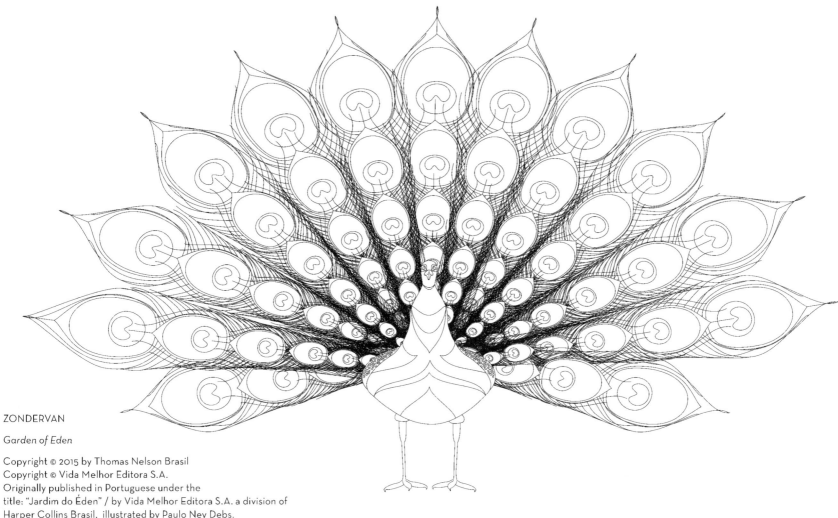

ZONDERVAN

Garden of Eden

Copyright © 2015 by Thomas Nelson Brasil
Copyright © Vida Melhor Editora S.A.
Originally published in Portuguese under the
title: "Jardim do Éden" / by Vida Melhor Editora S.A. a division of
Harper Collins Brasil, illustrated by Paulo Ney Debs.
All rights reserved to Ediouro Publishing Group

Requests for information should be addressed to:

Zondervan, 3900 *Sparks Dr. SE, Grand Rapids, Michigan 49546*

ISBN 978-0-310-75975-1

Illustrations: Paulo Ney Debs
Editor: Annette Bourland
Design: Cindy Davis

Printed in the United States

16 17 18 19 20 /DKI/ 19 18 17 16 15 14 13 12 11 10 9 8 7 6 5 4 3 2 1

The heavens declare
the glory of God;
the skies proclaim
the work of his hands.

—Psalms 19:1

In the beginning God created the heavens and the earth. (Genesis 1:1)

Now the earth was formless and empty, darkness was over the surface of the deep, and the Spirit of God was hovering over the waters. (Genesis 1:2)

Then God said, "Let the land produce vegetation." (Genesis 1:11)

The land produced vegetation ...
(Genesis 1:12)

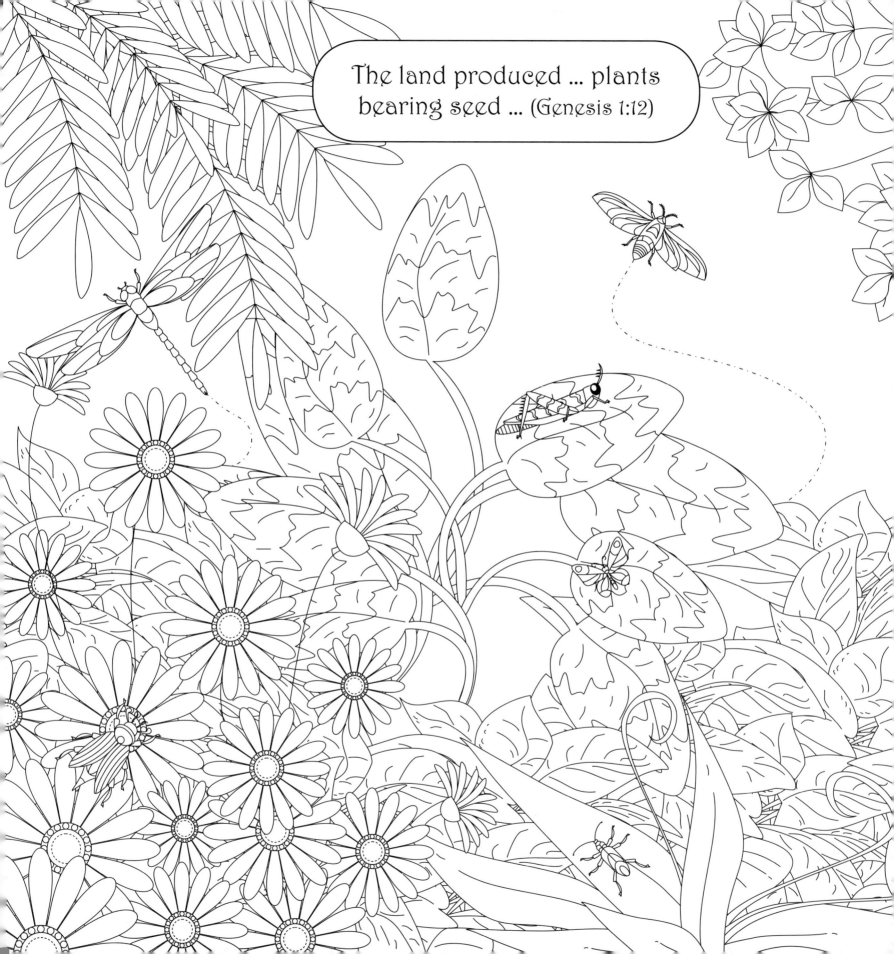

The land produced ... plants bearing seed ... (Genesis 1:12)

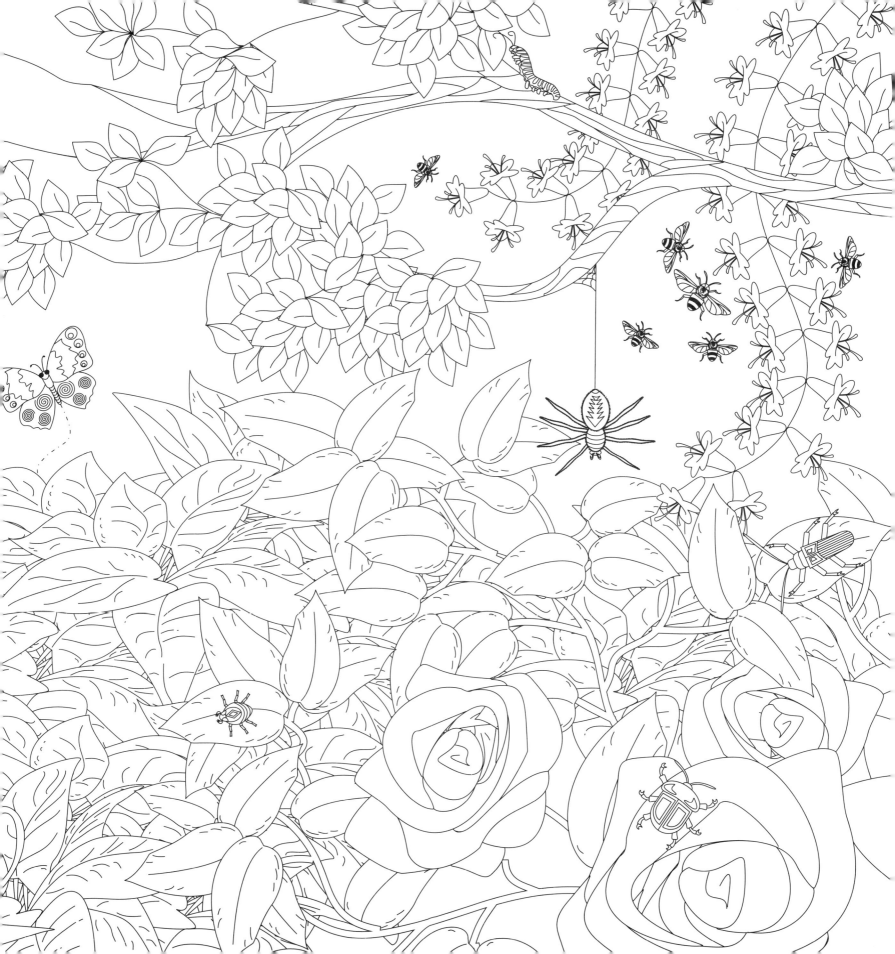

... plants bearing seed according to their kinds. (Genesis 1:12)

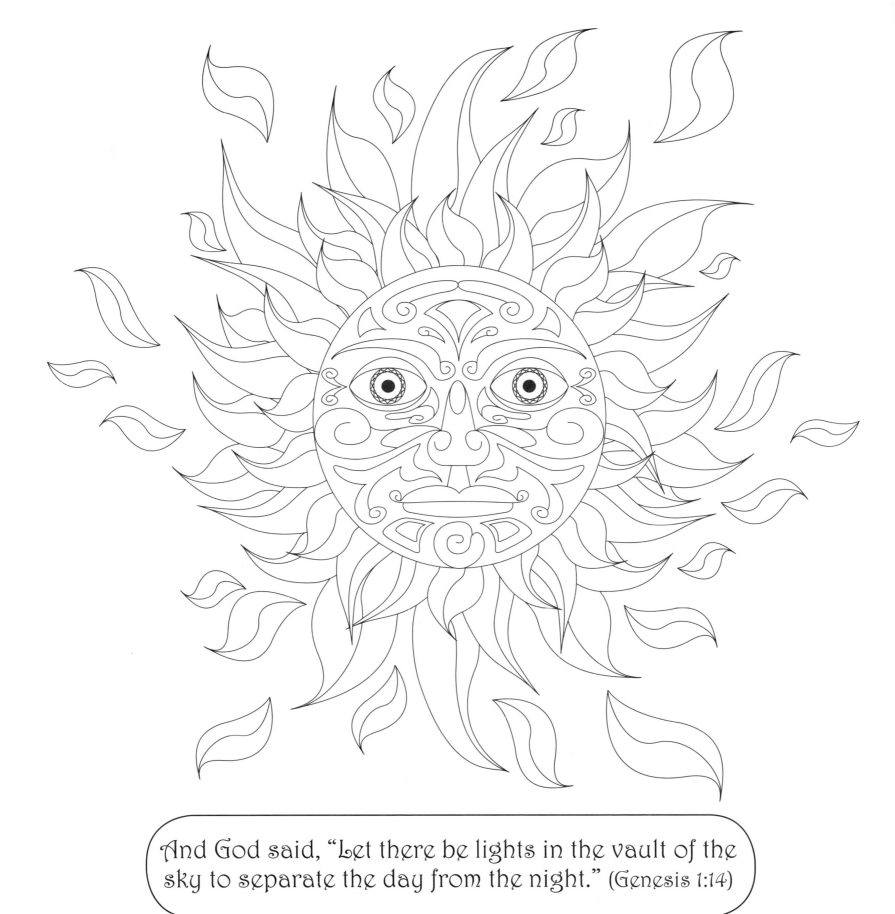

And God said, "Let there be lights in the vault of the sky to separate the day from the night." (Genesis 1:14)

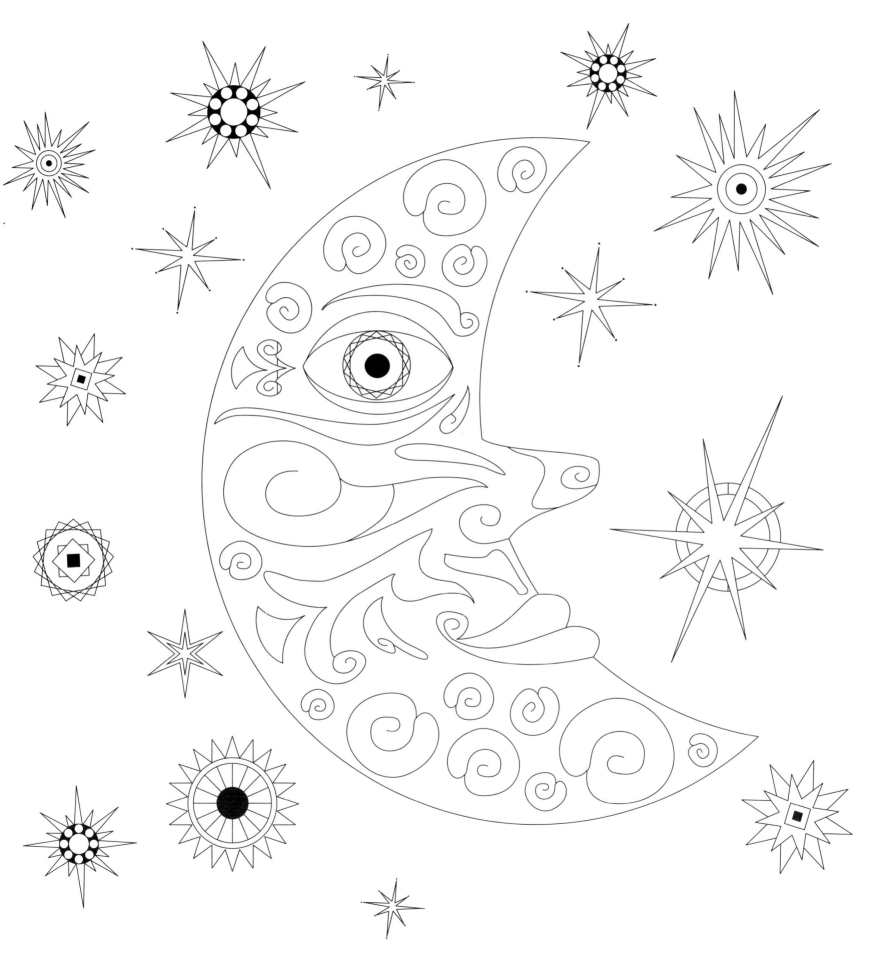

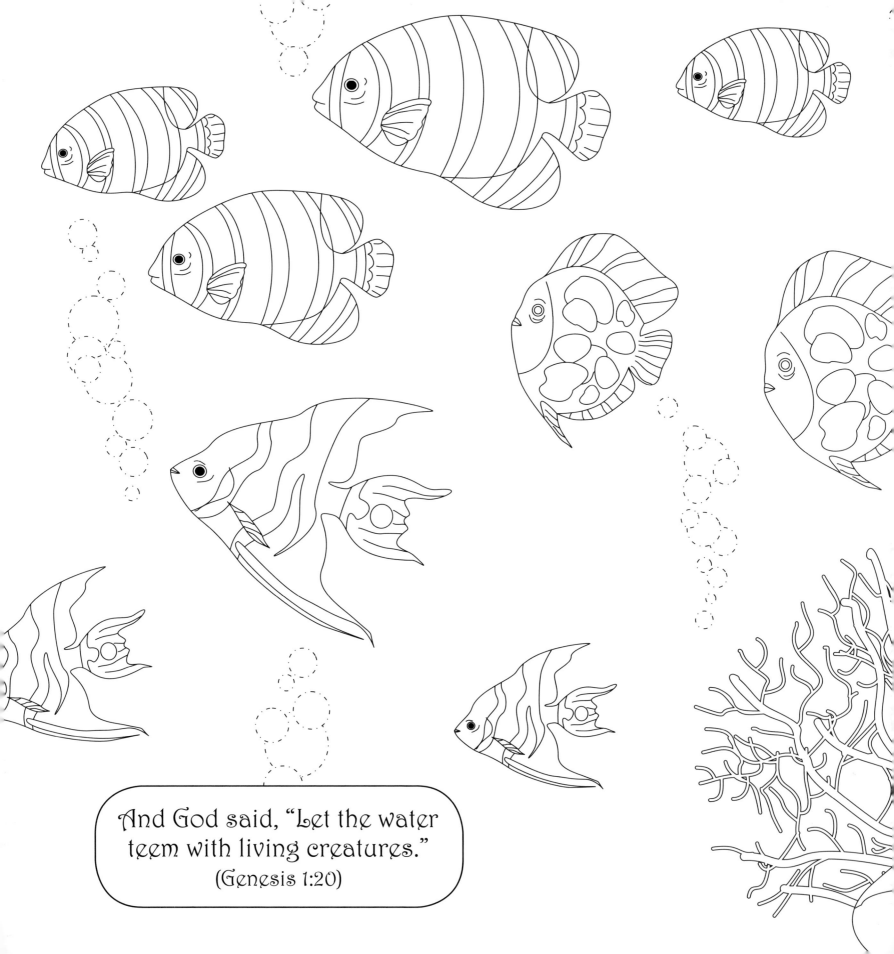

And God said, "Let the water teem with living creatures."
(Genesis 1:20)

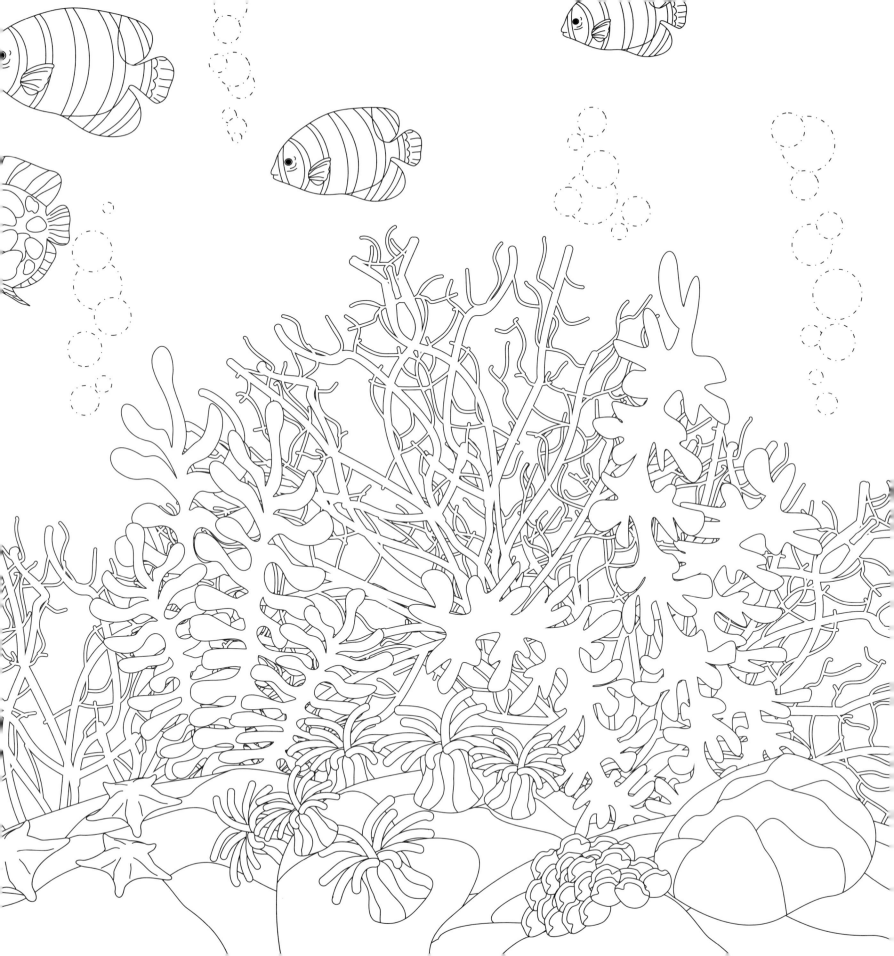

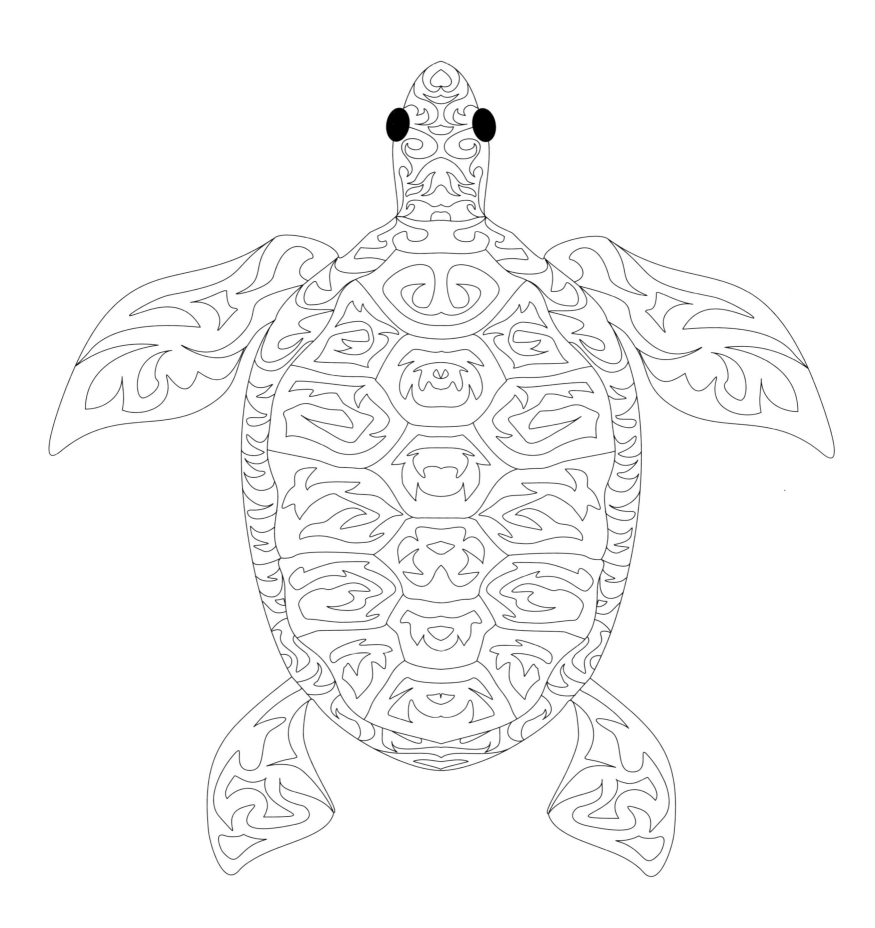

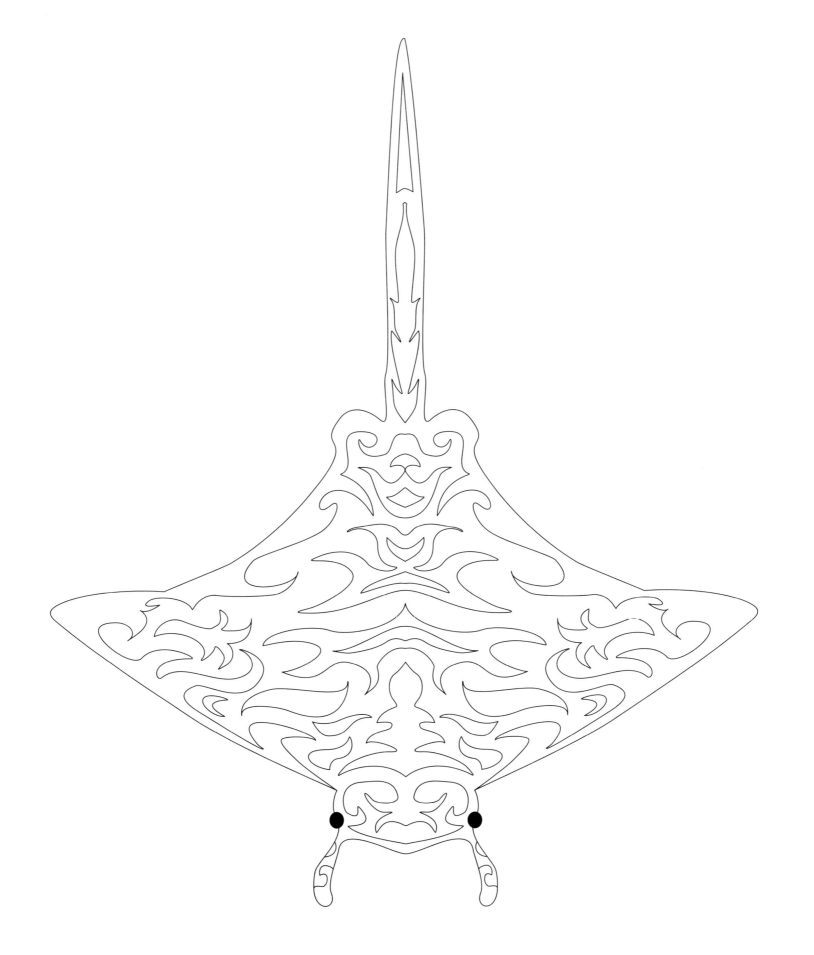

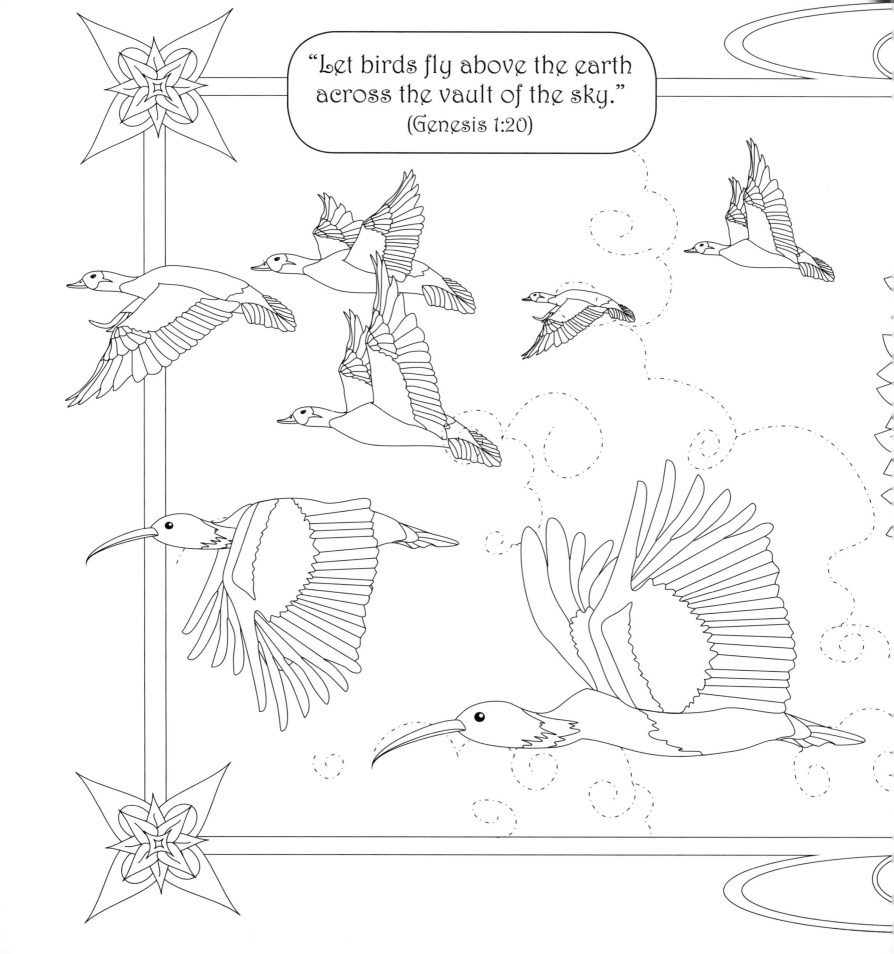

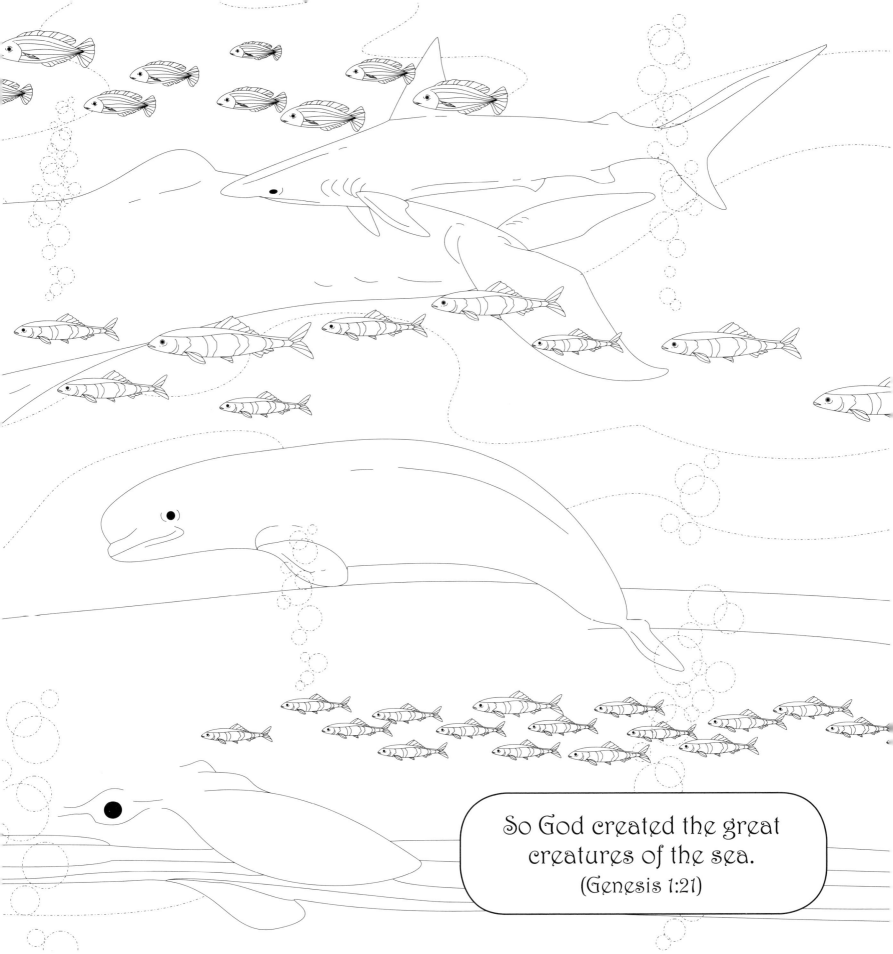

So God created the great creatures of the sea.
(Genesis 1:21)

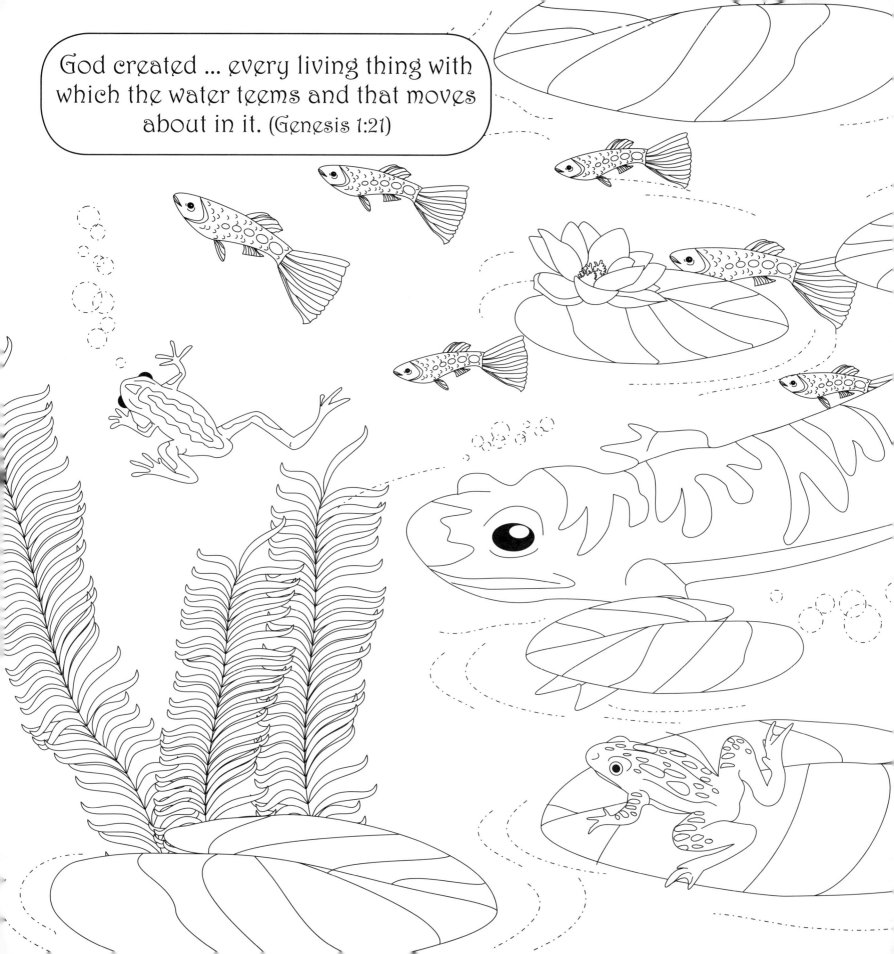

God created ... every living thing with which the water teems and that moves about in it. (Genesis 1:21)

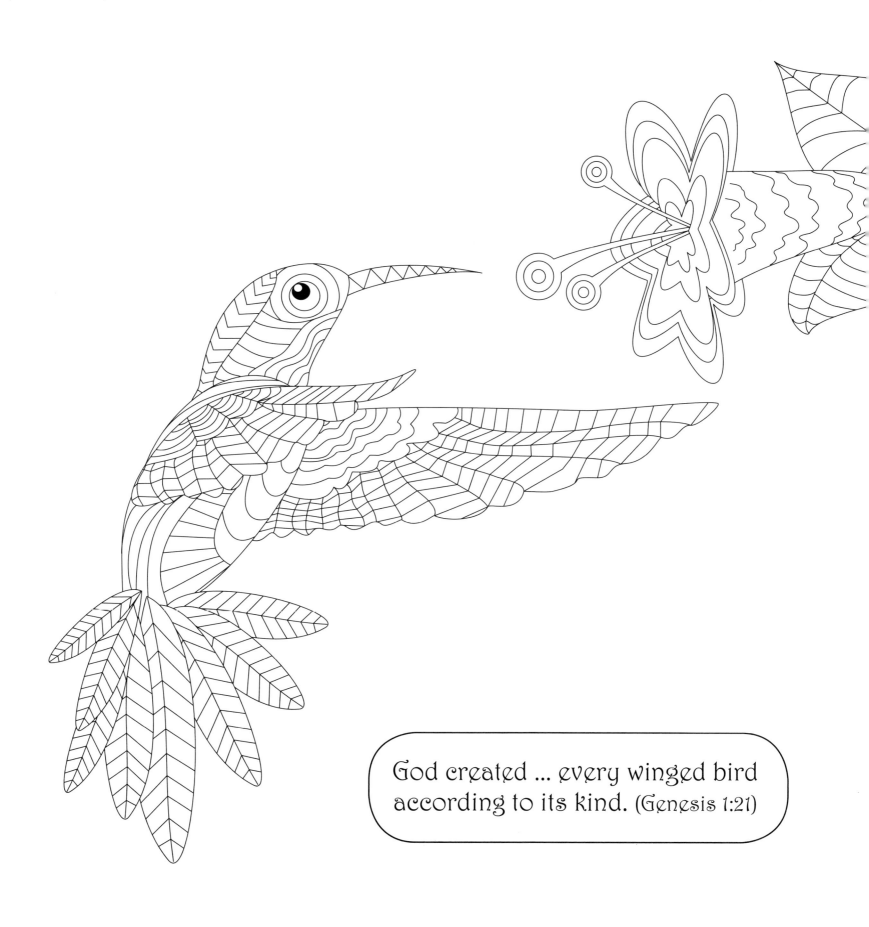

God created ... every winged bird according to its kind. (Genesis 1:21)

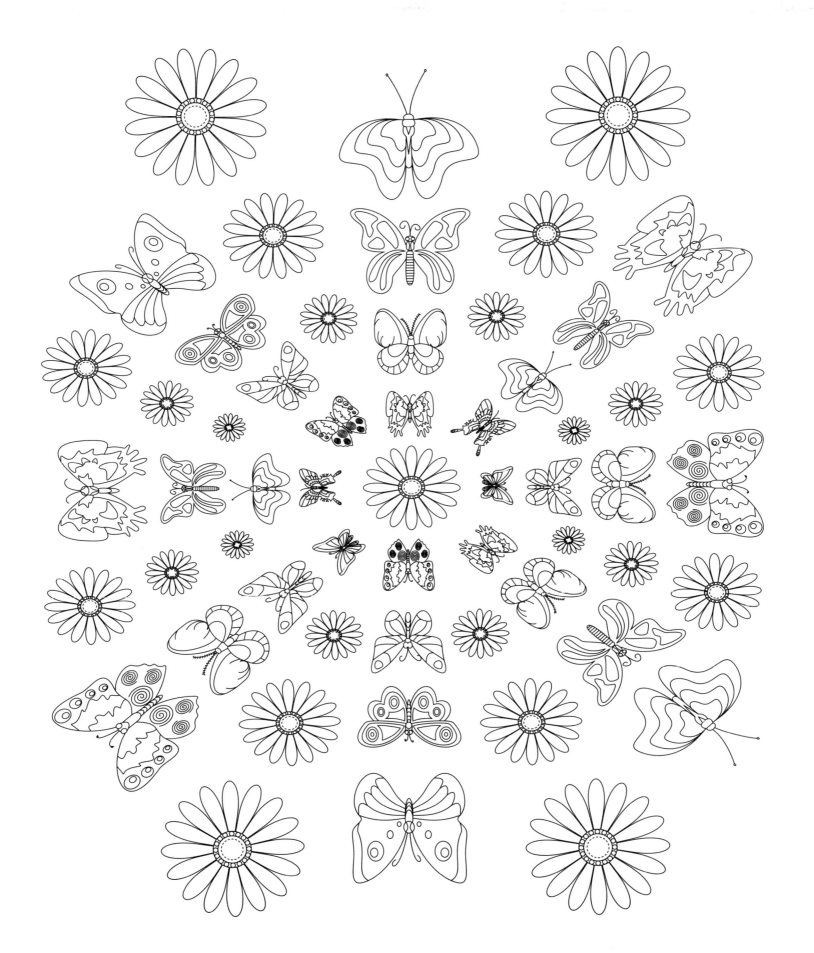

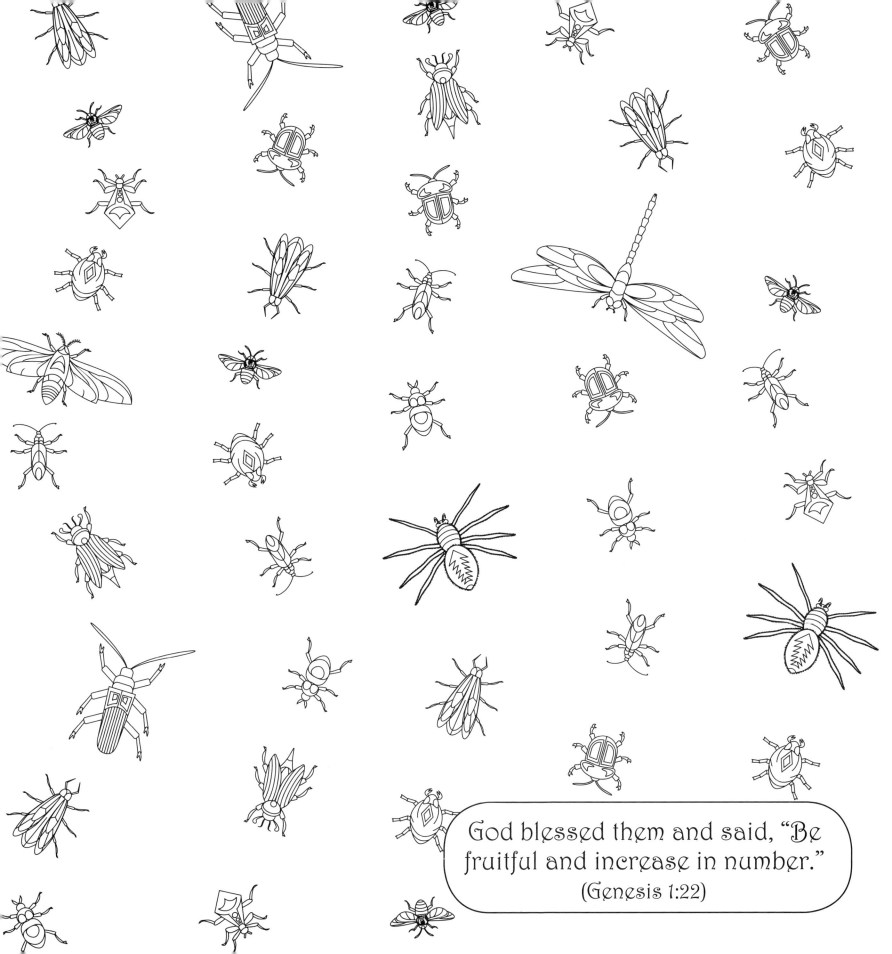

God blessed them and said, "Be fruitful and increase in number."
(Genesis 1:22)

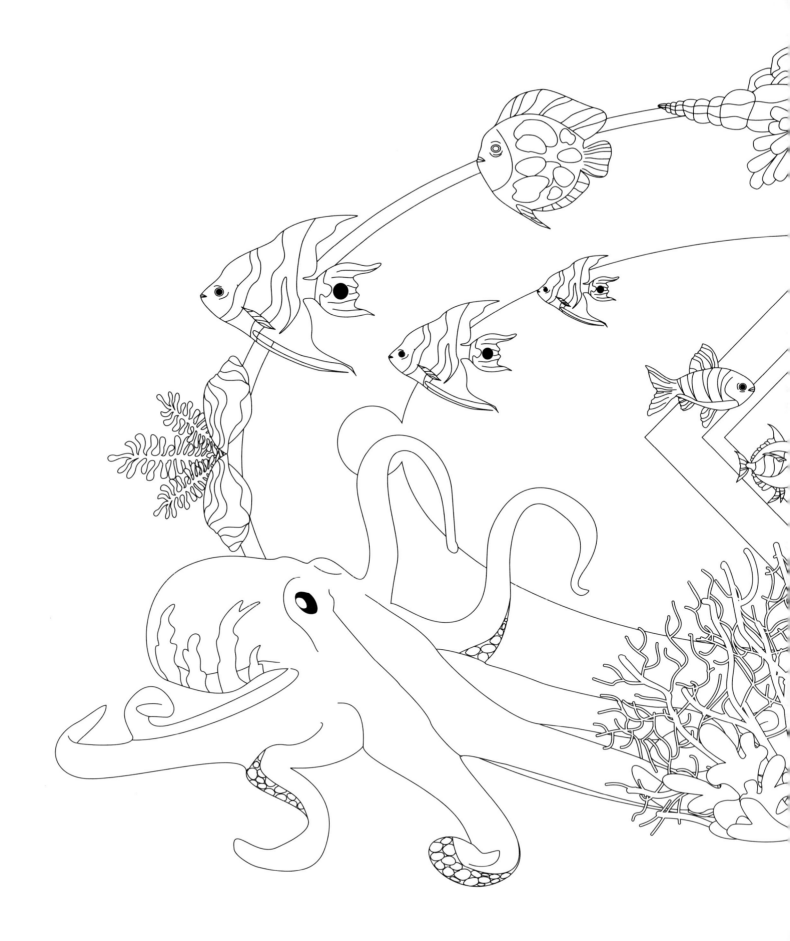

"Fill the water in the seas." (Genesis 1:22)

"Let the birds increase on the earth." (Genesis 1:22)

"Let the land produce wild animals." (Genesis 1:25)

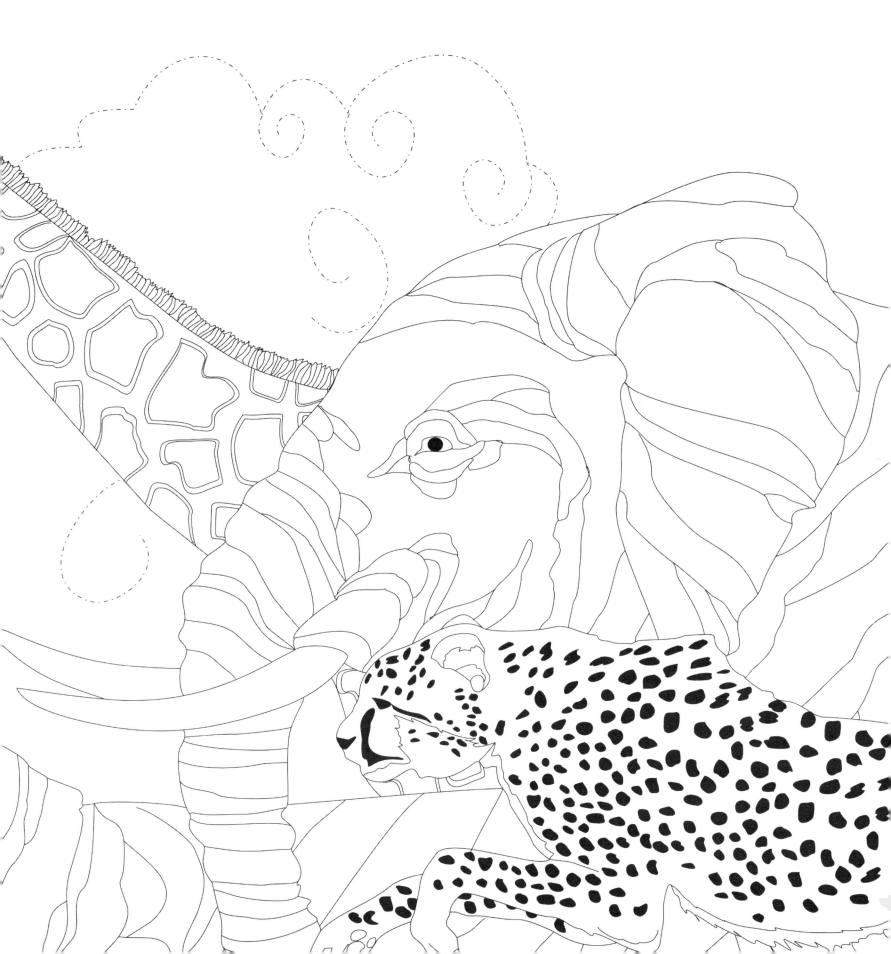

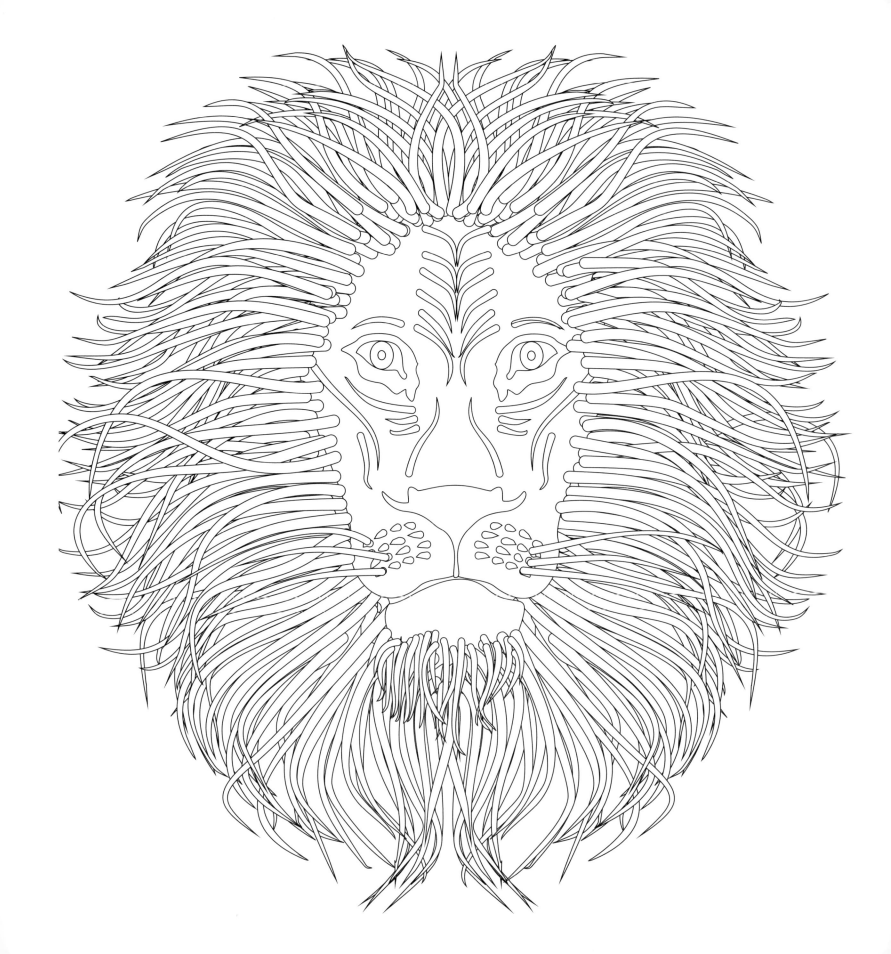

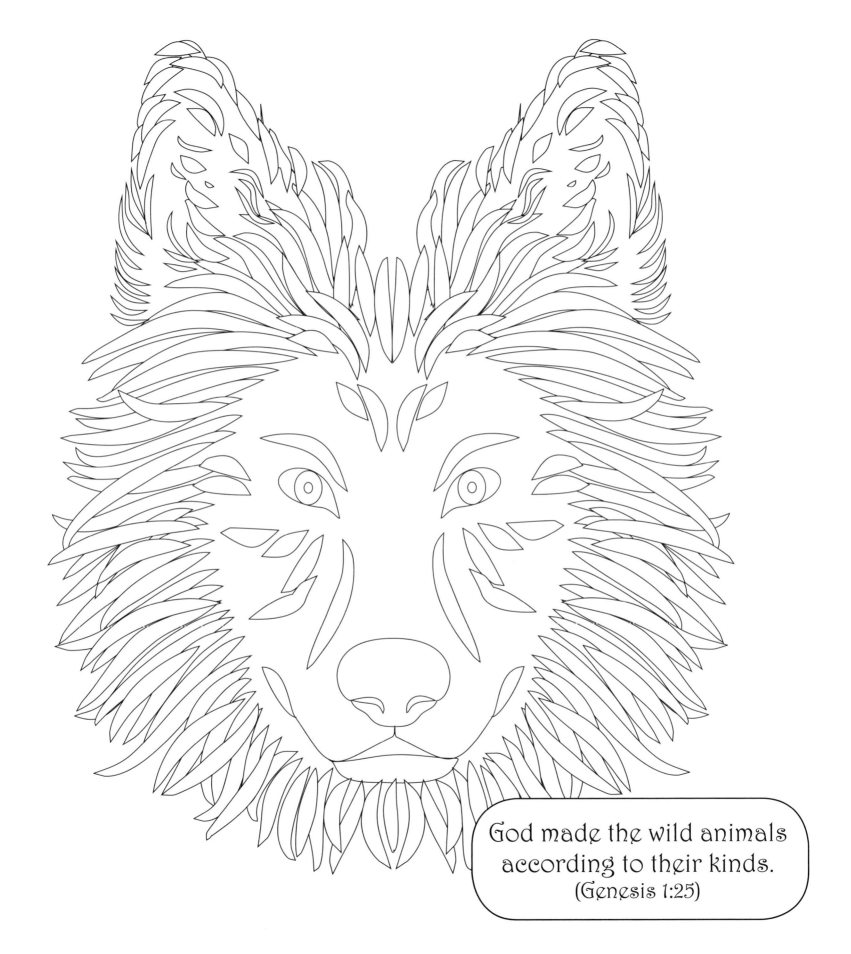

God made the wild animals
according to their kinds.
(Genesis 1:25)

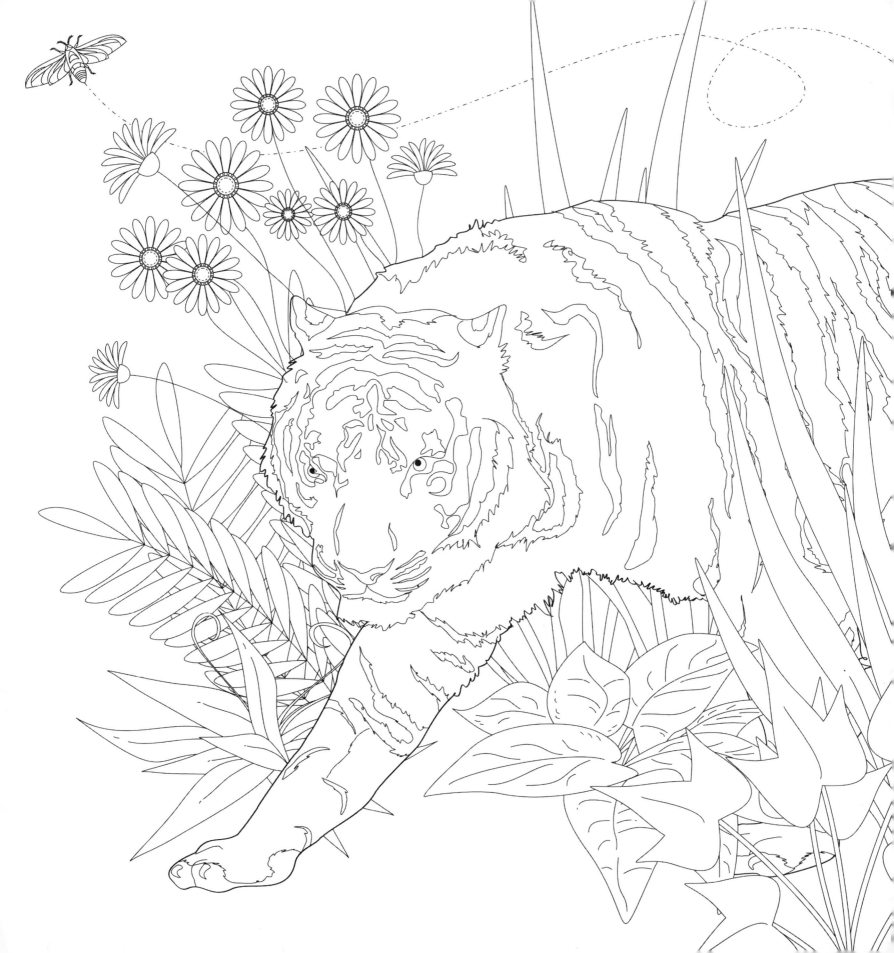

And God saw that it was good.
(Genesis 1:25)

So God created mankind in his own image, in the image of God he created them; male and female he created them. (Genesis 1:25)

God blessed them and said to them, "Be fruitful and increase in number; fill the earth and subdue it. Rule over the fish in the sea and the birds in the sky and over every living creature that moves on the ground." (Genesis 1:28)

This is the account of the heavens and the earth when they were created, when the LORD God made the earth and the heavens. (Genesis 2:4)

Now the LORD God had planted a garden in the east, in Eden. (Genesis 2:8)

The LORD God took the man and put him in the Garden of Eden to work it and take care of it. (Genesis 2:15)

So the man gave names to all the livestock, the birds in the sky and all the wild animals. (Genesis 2:20)

Then the LORD God made a woman. (Genesis 2:22)

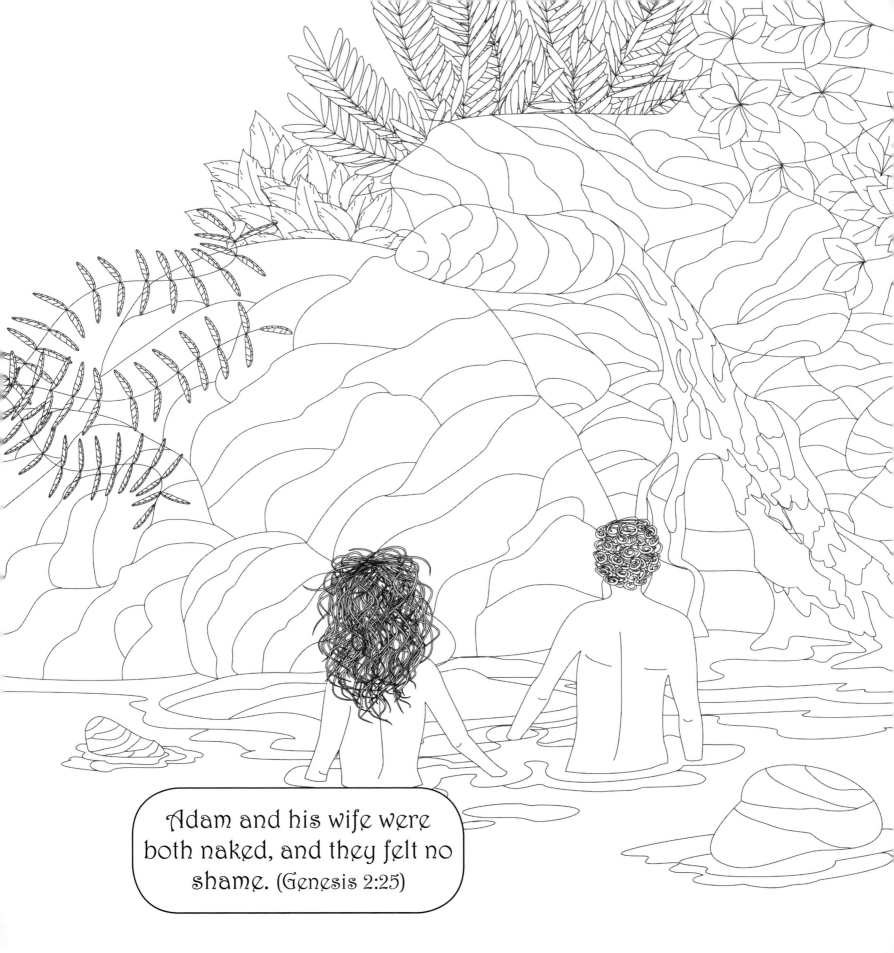

Adam and his wife were both naked, and they felt no shame. (Genesis 2:25)

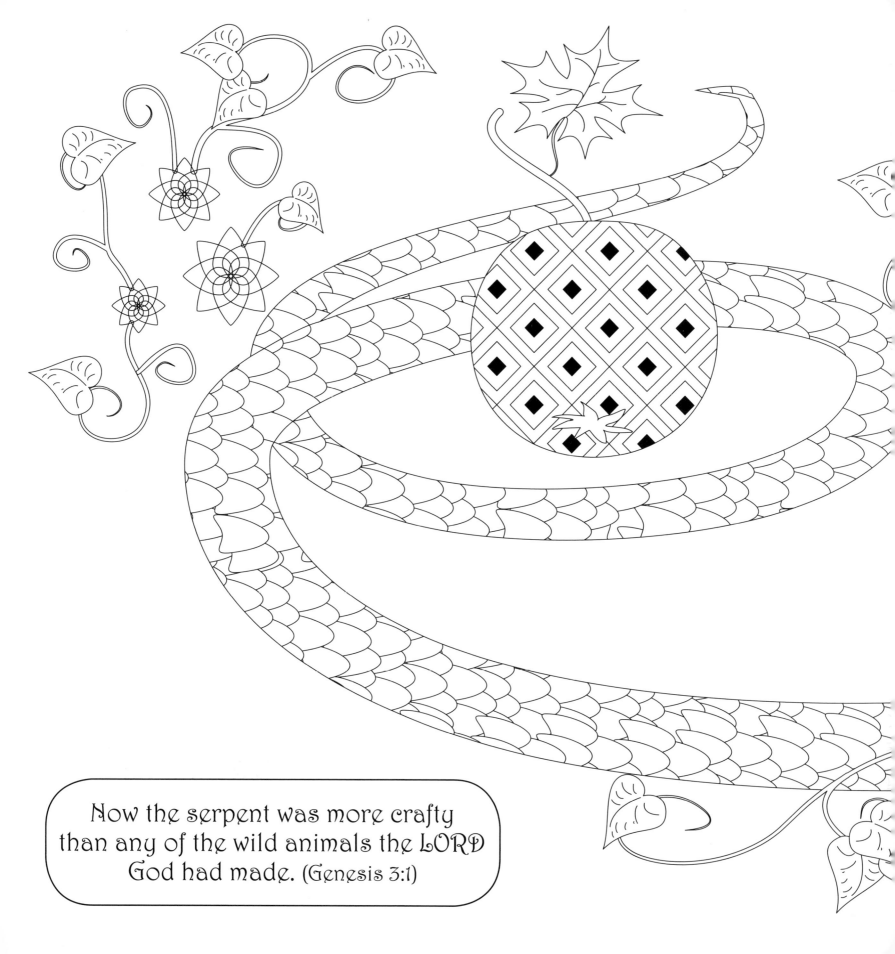

Now the serpent was more crafty than any of the wild animals the LORD God had made. (Genesis 3:1)

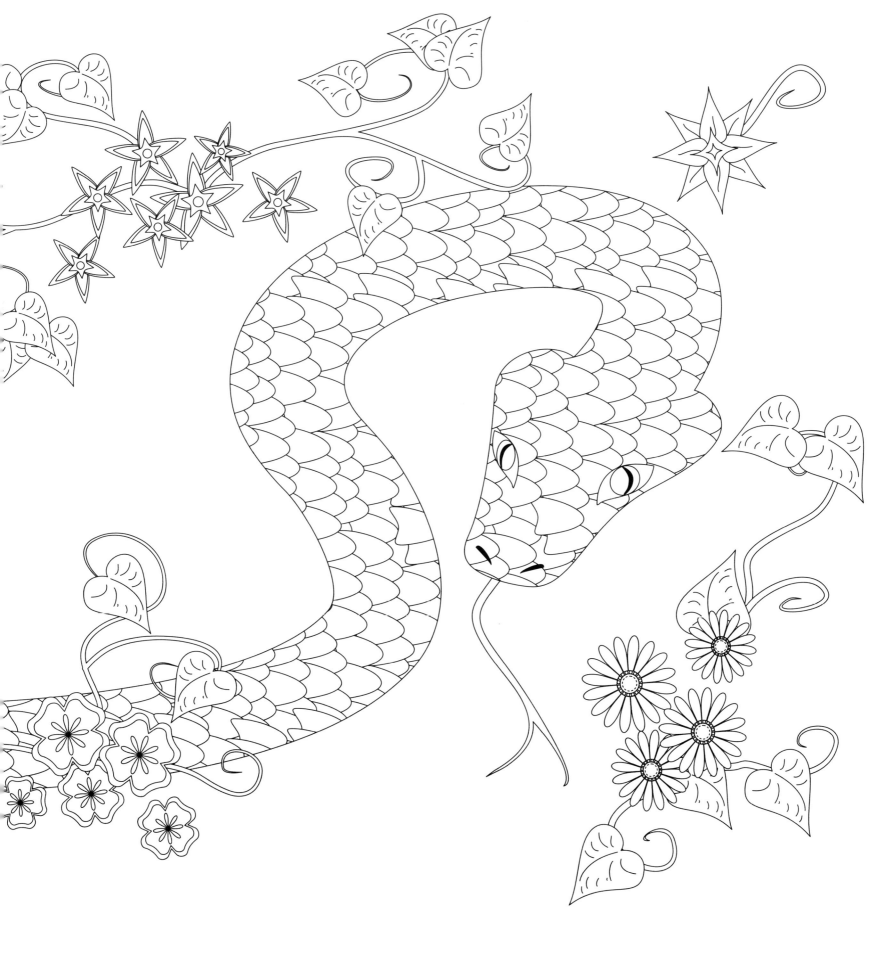

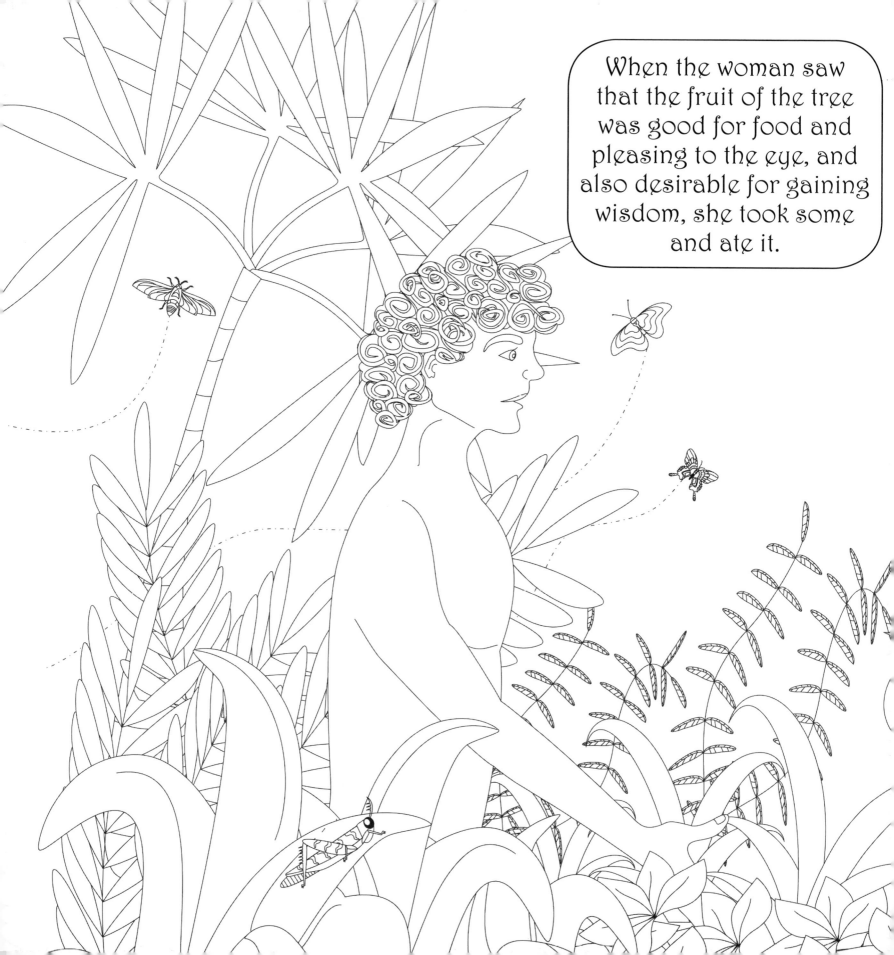

When the woman saw that the fruit of the tree was good for food and pleasing to the eye, and also desirable for gaining wisdom, she took some and ate it.

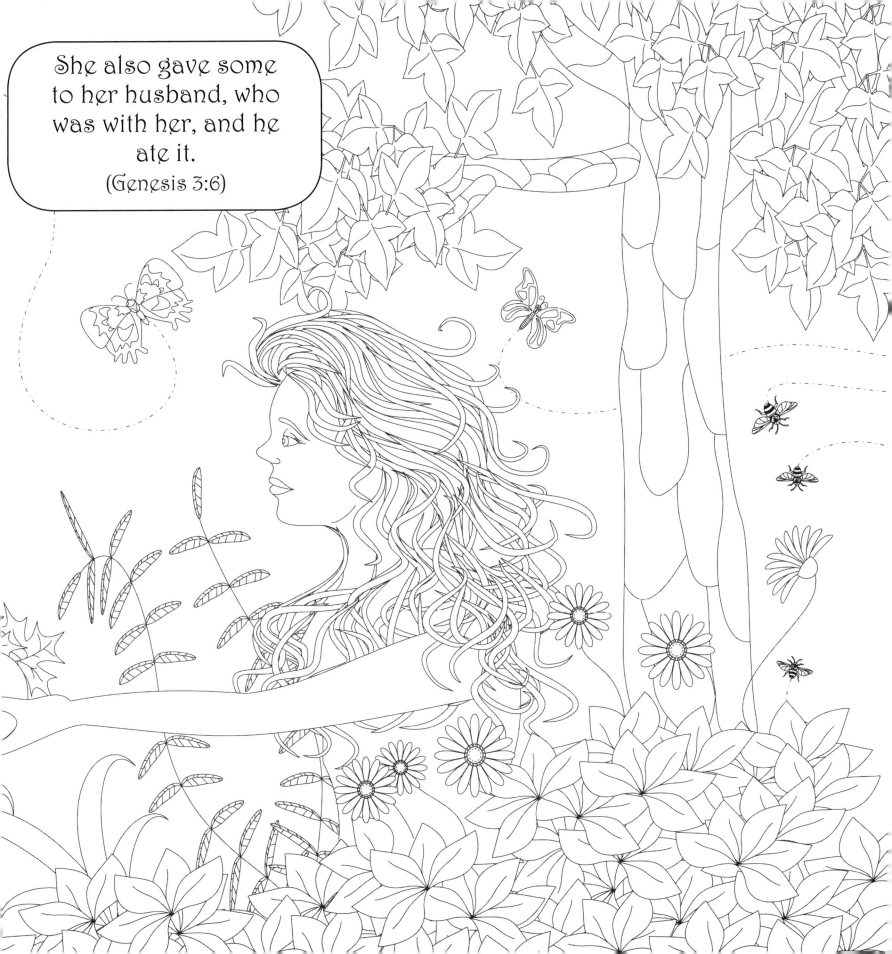

She also gave some to her husband, who was with her, and he ate it.
(Genesis 3:6)

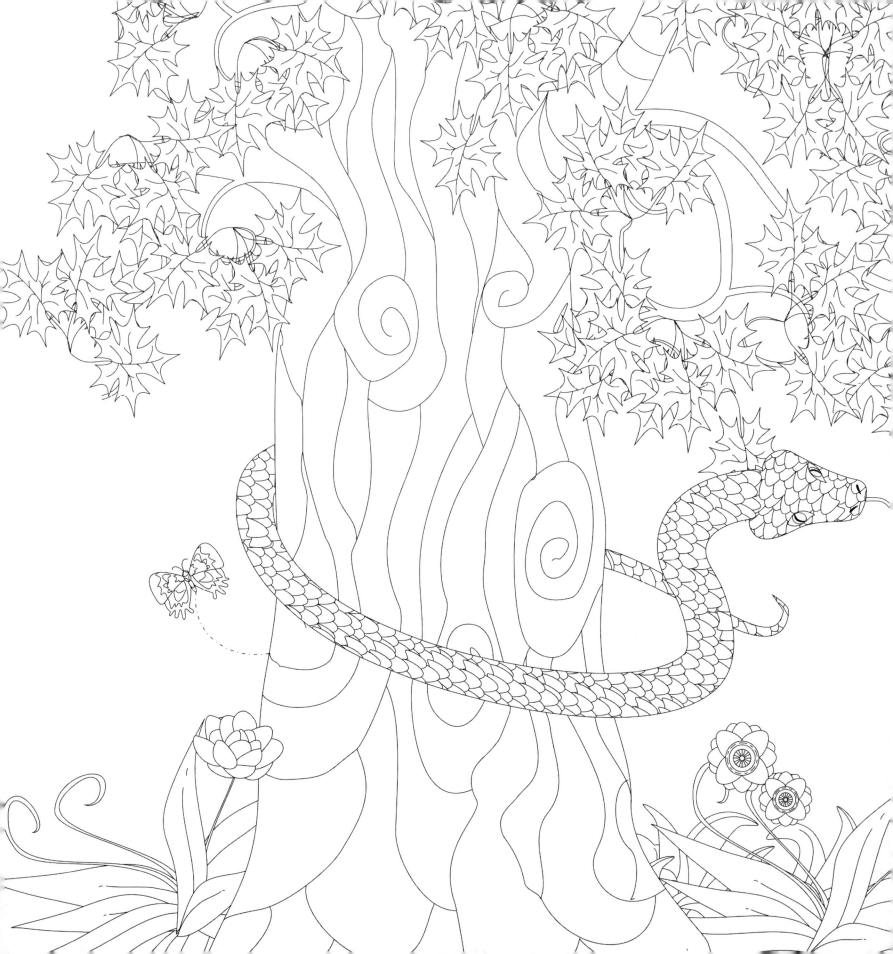

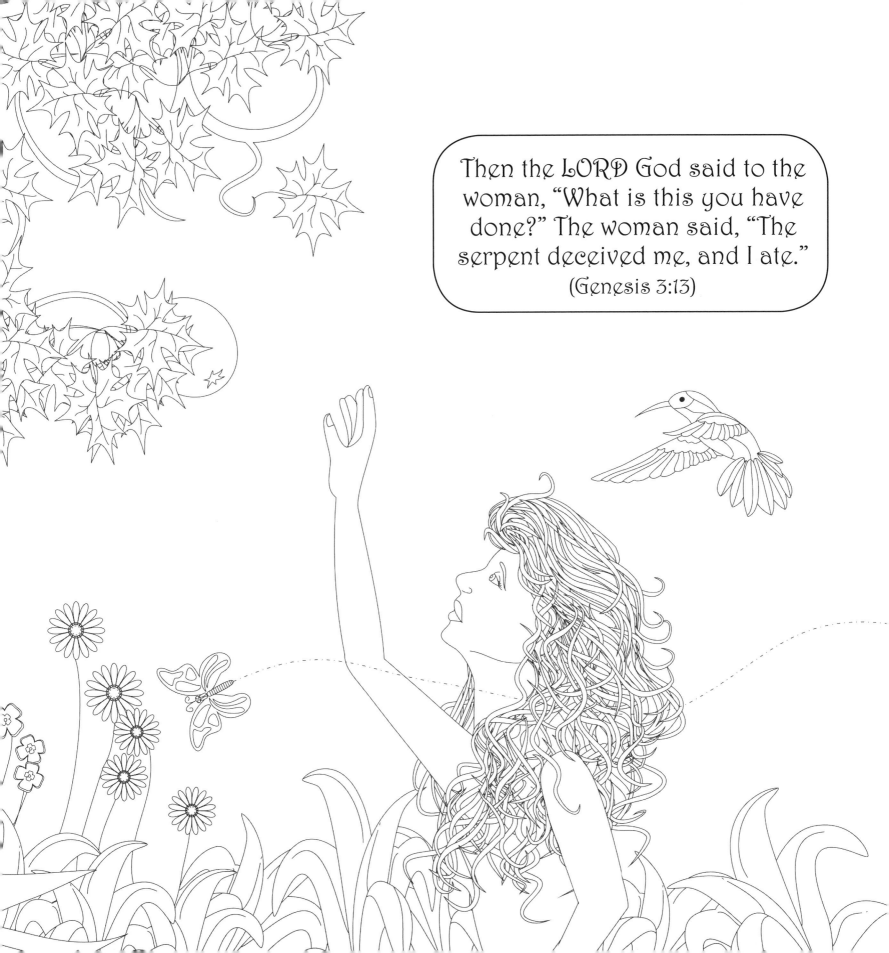

Then the LORD God said to the woman, "What is this you have done?" The woman said, "The serpent deceived me, and I ate."
(Genesis 3:13)

Inspiring Words

30 Verses from the Bible You Can Color

Take time to relax, sit back, and meditate on God's Word. Inside these pages, you'll find thirty unique and creative illustrations focusing on key verses from the Bible, each offering an opportunity to connect with Scripture while exploring your creativity. Throughout, NIV verses are paired with detailed line art, and each page is printed on high-quality, thick paper stock that won't bleed through. And when you're finished coloring with markers, pens, watercolors, or colored pencils, the completed page can be removed, allowing you to display your work for even more daily inspiration.

Softcover: 9780310757283

Available in stores and online!

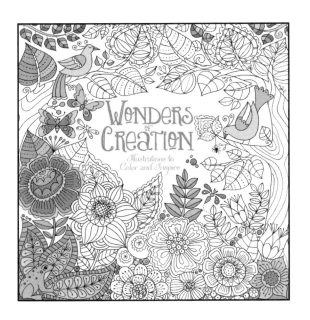

Wonders of Creation

Illustrations to Color and Inspire

Wonders of Creation explores the wonders of our created world though detailed black-and-white illustrations—each one ready to be filled with the hues of your imagination. From amazing Eden-esque gardens to the creatures God made that still ramble through our world, this ninety-six-page book offers hours of coloring inspiration and relaxation for any age.

Appeals to all ages looking for a unique coloring experience.

Softcover: 9780310757399

Available in stores and online!

ZONDERVAN®
.com

"You are worthy, our Lord and God,
to receive glory and honor and power,
for you created all things, and by your
will they were created and have their being."

—Revelation 4:11